MW01129803

SCOTTISH KINGS AND QUEENS

By Elizabeth Douglas
Illustrated by Adrienne Salgado

NMS | National Museums of Scotland

KINGS AND QUEENS— WHAT ARE THEY AND WHAT DO THEY DO ?

At one time, most European countries were ruled by kings and queens. Some countries still have them. There are kings or queens today in Norway, Sweden, Denmark, the Netherlands, Belgium and Spain—just like the United Kingdom.

Of course, there have been many changes in the role of the monarch through history. Kings and queens are no longer expected to lead their soldiers into battle nor are they likely to be executed should events take a turn for the worse.

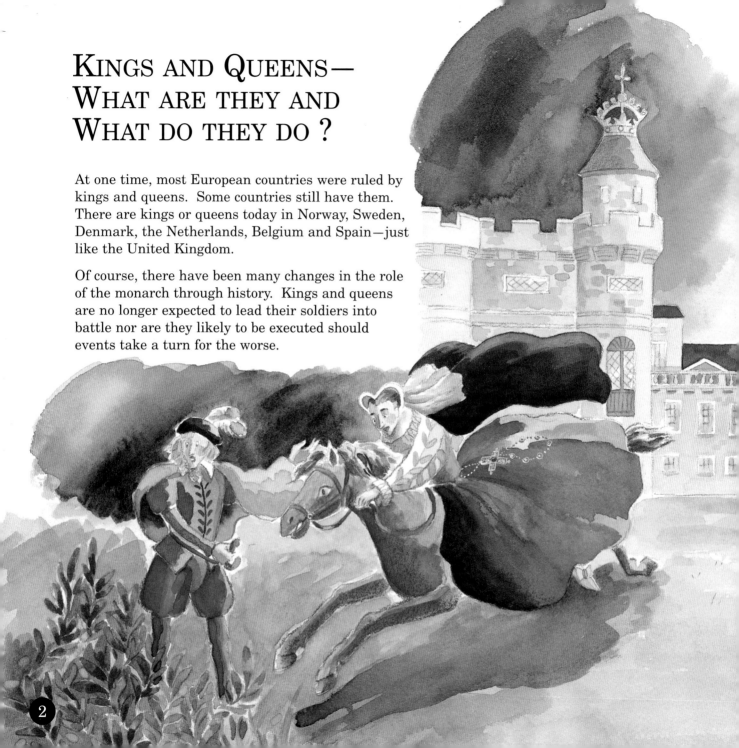

For upward of 750 years, Scotland had its own kings and queens. The Queen of the United Kingdom of Great Britain and Northern Ireland is descended from them. Queen Elizabeth II makes regular visits to Scotland, for official engagements and for holidays at Balmoral Castle.

Queen Elizabeth II leaves the day-to-day running of the United Kingdom to her Prime Minister and Government. The Queen has regular meetings with the Prime Minister who keeps her up to date with affairs of Parliament.

As you read through this book you will discover similarities and differences between the life and role of our Queen and that of kings and queens in the past. See how how many of these similarities and differences you can find.

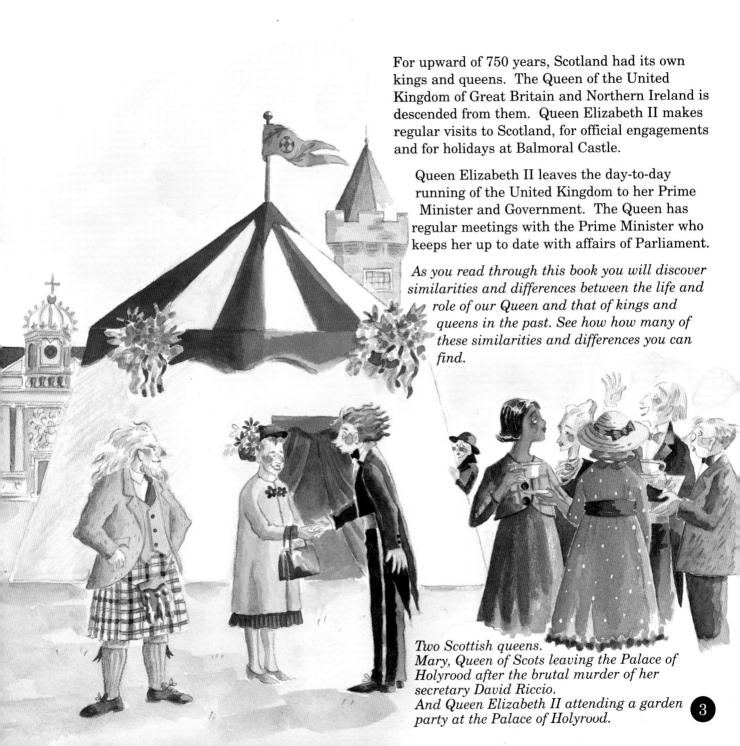

Two Scottish queens.
Mary, Queen of Scots leaving the Palace of Holyrood after the brutal murder of her secretary David Riccio.
And Queen Elizabeth II attending a garden party at the Palace of Holyrood.

3

Royal Signs

Throughout history Scottish kings and queens have had special signs which show their subjects that they are the monarchs of that country. They might also show where the monarch is. For instance, when Queen Elizabeth II is staying in Edinburgh at the Palace of Holyroodhouse you can see the Royal Banner or Flag flying from the pole above the Palace.

The Stone of Destiny
The Stone of Destiny was the throne upon which the Kings of Scotland were crowned. It was situated in Scone, near Perth, once the capital of the kingdom of the Scots and Picts. In 1296 King Edward I of England took the Stone to London. He put it under his own throne in Westminster Abbey. Since the time of King Edward I many kings and queens have been crowned on this throne including Queen Elizabeth II. The stone was returned to Scotland in November 1996 and installed in the Crown Room in Edinburgh Castle on St. Andrew's Day, 30th November 1996.

The Royal Coat of Arms
The Royal Coat of Arms used by Queen Elizabeth II in Scotland is made up of several important symbols. These symbols represent the countries which make up the United Kingdom. There is a unicorn, holding the saltire or St. Andrew's Cross, representing Scotland. There is a lion which holds the Cross of St. George, representing England. Between the two creatures is a shield showing the Lion Rampant of Scotland and the three lions of

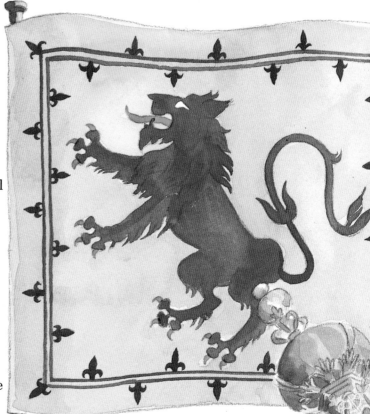

England. There is a third symbol on the shield, a harp. Do you know which country this represents?

The Lion Rampant Flag
King William I, known as William the Lion, reigned in Scotland between 1165 and 1214. When he went into battle he had a red lion standing on its hind legs on a yellow background painted on his shield. He used this symbol so that he would be recognised. His Lion Rampant flag became the Royal Flag or Banner of the kings and queens of Scotland.

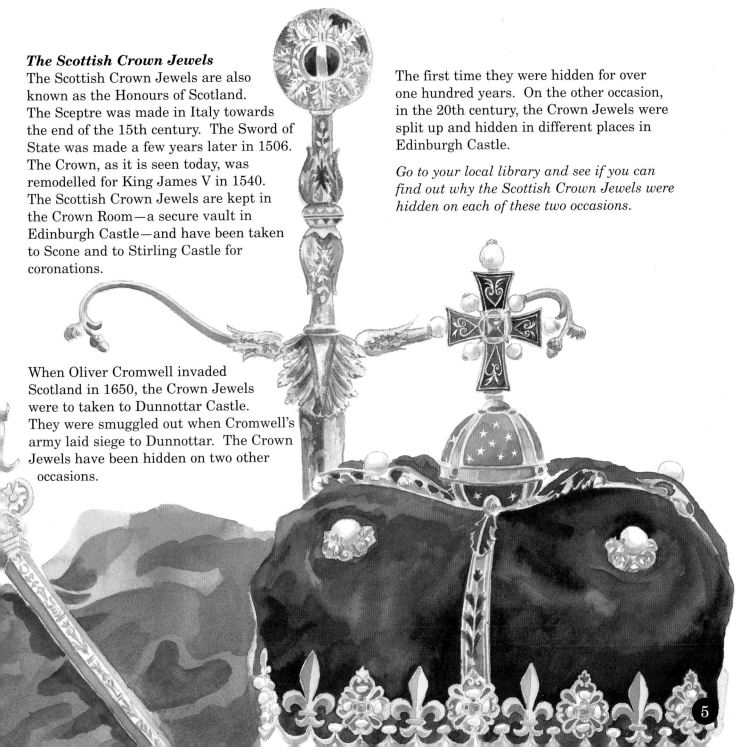

The Scottish Crown Jewels

The Scottish Crown Jewels are also known as the Honours of Scotland. The Sceptre was made in Italy towards the end of the 15th century. The Sword of State was made a few years later in 1506. The Crown, as it is seen today, was remodelled for King James V in 1540. The Scottish Crown Jewels are kept in the Crown Room—a secure vault in Edinburgh Castle—and have been taken to Scone and to Stirling Castle for coronations.

When Oliver Cromwell invaded Scotland in 1650, the Crown Jewels were to taken to Dunnottar Castle. They were smuggled out when Cromwell's army laid siege to Dunnottar. The Crown Jewels have been hidden on two other occasions.

The first time they were hidden for over one hundred years. On the other occasion, in the 20th century, the Crown Jewels were split up and hidden in different places in Edinburgh Castle.

Go to your local library and see if you can find out why the Scottish Crown Jewels were hidden on each of these two occasions.

THE EARLY SCOTTISH KINGS

Before the middle of the 9th century five different groups of people lived in Scotland. They each had their own monarchs. The Picts lived in the land from Caithness to the Firth of Forth. The Scots came across the sea from Dalriada, the land which is now Northern Ireland. They lived in Argyll and gave their name to Scotland. The Britons lived in Strathclyde and the Angles lived in Lothian. The Norse settlers, from Scandinavia, lived in the Orkneys, Shetlands and Western Isles.

Kenneth Macalpin
Kenneth Macalpin was King of the Scots and succeeded to the Pictish throne in A.D. 843. He was the first king to rule over such a large part of Scotland. He made his capital at Scone.

King Constantine I
Rather than inheriting the throne, King Constantine I was chosen to be king. He was chosen because he was a brave warrior and had a lot of supporters. This method of choosing a king was popular in the days when kings had to be powerful leaders. But it also led to a lot of Scottish kings dying violent deaths, often in mysterious circumstances. Scotland had no shortage of brave warriors, so it got through a lot of kings in a relatively short space of time. You can see their names on the inside front cover.

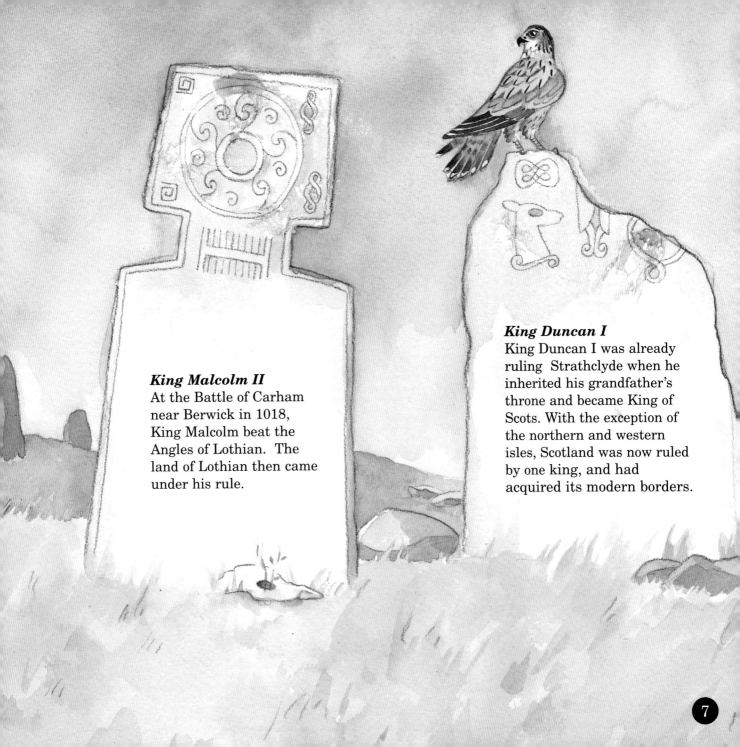

King Malcolm II
At the Battle of Carham near Berwick in 1018, King Malcolm beat the Angles of Lothian. The land of Lothian then came under his rule.

King Duncan I
King Duncan I was already ruling Strathclyde when he inherited his grandfather's throne and became King of Scots. With the exception of the northern and western isles, Scotland was now ruled by one king, and had acquired its modern borders.

MACBETH

After Macbeth killed Duncan I in battle in 1040 Duncan's son, Malcolm, was thought to be too young to be a strong king. Macbeth and his wife, Gruach, were descendants of Kenneth Macalpin and had a strong claim to the throne. So Macbeth was chosen as the new king by the most important Lords, or Mormaers, of Scotland. Macbeth was the last king to be chosen in this way. There were seven Mormaers in Scotland. Macbeth was the Mormaer of Moray in the north of Scotland.

Macbeth ruled Scotland for seventeen years. It was a reasonably peaceful time throughout the land. Macbeth made sure of this by sending groups of soldiers to travel around the land keeping a watchful eye on the country and the people. It was so peaceful in Scotland that Macbeth felt able to leave the country and go on a pilgrimage to Rome. It is possible that on this pilgrimage Macbeth was accompanied by his cousin Thorfinn. Thorfinn was the Norse Earl of Orkney and had been a claimant to the throne of Scotland at the same time as Macbeth.

In 1057 Malcolm, the son of Duncan I, returned to Scotland. He gathered an army and confronted Macbeth and his army at Lumphanan. Macbeth was killed in the fighting. His stepson Lulach, in line for the throne, was captured at Strathbogie by Malcolm and put to death.

Macbeth and Thorfinn travelled together on a pilgrimage to Rome.

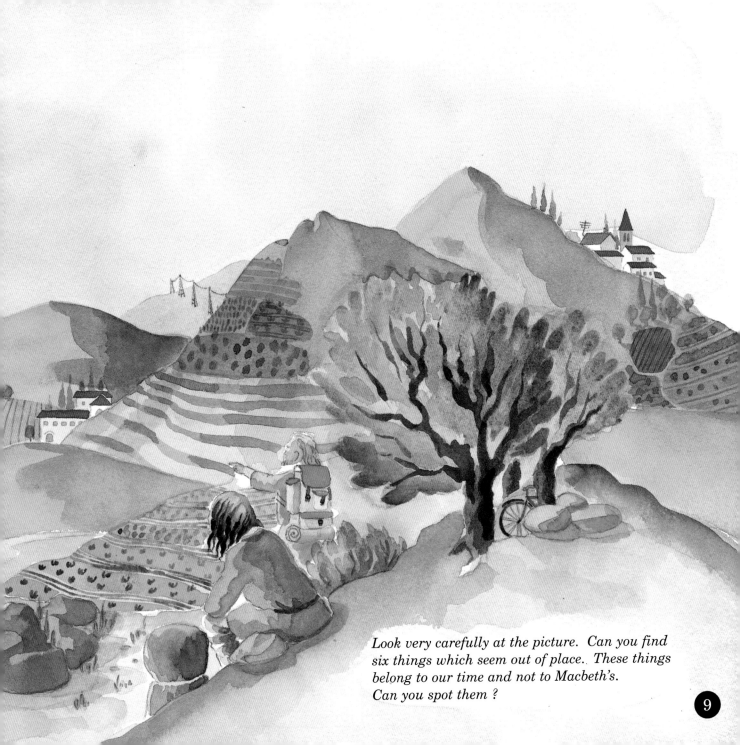

Look very carefully at the picture. Can you find six things which seem out of place. These things belong to our time and not to Macbeth's. Can you spot them?

9

William the Conqueror was Duke of Normandy, in France. He invaded England and killed King Harold of England at the Battle of Hastings in 1066. He declared himself the new King of England. Edgar Atheling was the heir to the English throne. He did not have enough support in England and was advised to leave the country. His sister Princess Margaret and her family travelled to Scotland with him for safety and King Malcolm III welcomed this party of royal exiles to his court in Dunfermline.

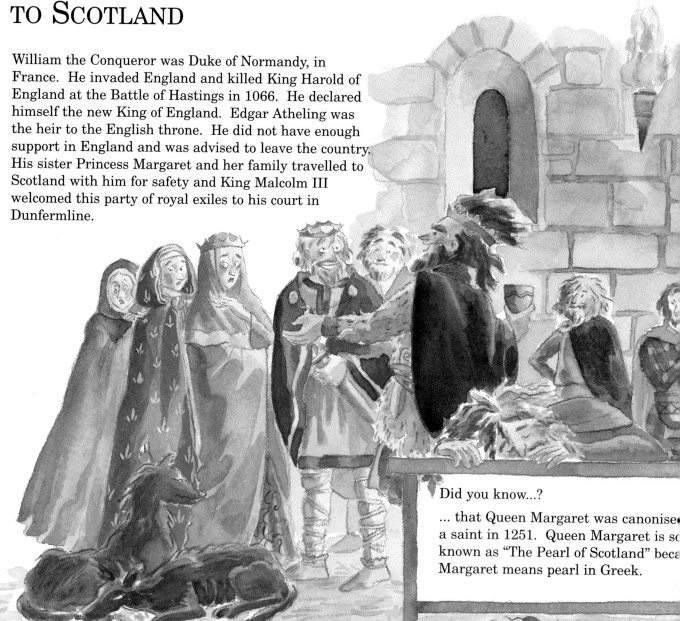

Did you know...?

... that Queen Margaret was canonise[d] a saint in 1251. Queen Margaret is s[o] known as "The Pearl of Scotland" beca[use] Margaret means pearl in Greek.

In 1069 Margaret and her family returned to England only to leave again soon after. They were heading for the court of King Stephen of Hungary where they had grown up. Stormy weather forced the ship they were sailing in to land, possibly somewhere along the Fife coast. King Malcolm was happy to welcome Margaret back to his court. Margaret had strong religious beliefs and had wanted to become a nun, but in 1070 King Malcolm persuaded her to marry him. Thus Margaret became Queen of Scotland.

Queen Margaret helped many people. She gave away expensive gifts from King Malcolm to the poor. On one occasion Queen Margaret and King Malcolm served food to hungry beggars in the banqueting hall of their palace at Dunfermline.

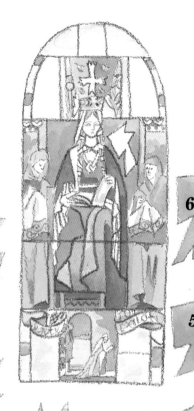

King Malcolm welcomed Princess Margaret back to Scotland.

nade
mes ... that North and South Queensferry were named after Queen Margaret. She had ferries sail between these two points on the Firth of Forth carrying pilgrims on their way to St. Andrews.

Saint Margaret's Chapel is the oldest building in Edinburgh Castle. It may have been built by King David I in honour of his mother.

If you get a chance to visit Saint Margaret's Chapel you will see a beautiful stained glass window which shows the Scottish Queen. This is a picture of that window. There is one piece of glass missing. Look at the shapes below the window. Which one do you think is the missing piece ?

KING DAVID I

King David I was a deeply religious person like his mother, Queen Margaret. During his 29-year reign he was responsible for the building of many new abbeys and monasteries. There is a famous legend about King David and the founding of Holyrood Abbey, in Edinburgh.

One day King David was hunting in the woods surrounding his palace in Edinburgh. At this time, what is now the Queen's Park around

King David held up the cross between himself and the stag.

Arthur's Seat was covered with trees. The King was hunting for deer when he was thrown from his horse. At that moment a huge stag crashed through the trees and headed straight for the King. King David knew that he was in a very dangerous situation. Being a very religious man he prayed for help. As he prayed a wooden cross or "rood" appeared between the stag's antlers. As soon as the King took hold of the cross the stag turned and left him unharmed. To show his thanks and joy for being saved King David had the Abbey of "the Holy Rood" built, in 1128, supposedly on the spot where he had faced the stag.

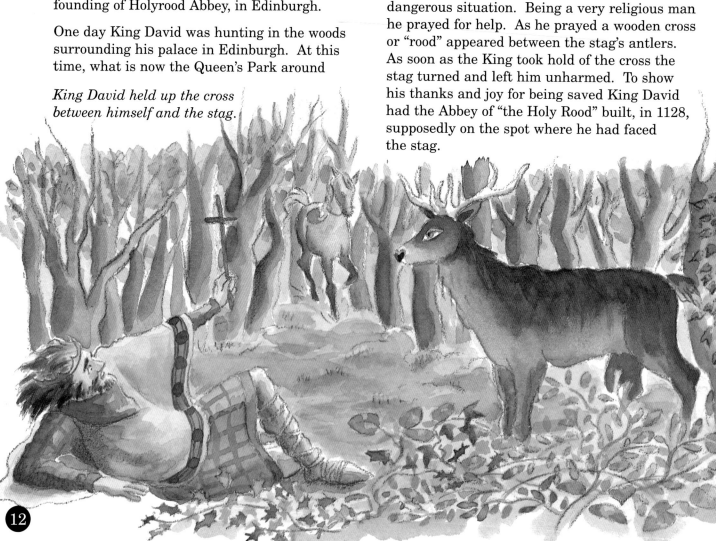

Did you know...?

... that some of the first castles in Scotland were built in the reign of King David I.

... that King David I introduced a system of land ownership to Scotland called feudalism. A landowner rented out his land to another person in return for money. This person had to promise to be loyal to his landlord and to fight for him in battle, if asked.

King David was brought up at the English court. When he became king of Scotland he encouraged his English and Norman friends to come north with him. He gave them land on which to build castles. Amongst the noblemen who came to Scotland were the ancestors of future kings of Scotland. Walter Fitz-Alan was made Hereditary High Steward and was the ancestor of the Stewart Royal Family. The de Ballieul and the de Brus' families also came to Scotland at this time. Do you know the names of their descendants who became kings of Scotland ?

13

TROUBLES WITH THE NORSEMEN

Norsemen had lived in the Orkneys, Shetlands and Western Isles since the 9th century. Arriving in their longboats from Scandinavia, they had settled in the islands. They were governed by Norse kings.

Around 1230, Norse raiders attacked Rothesay. Alexander II ordered that all castles which might come under attack were to be strengthened. The Scottish king offered the Norse king, Haakon, money for the islands. King Haakon refused to sell his land. In 1249, King Alexander gathered a fleet of ships and planned to sail to the northern isles to confront the Norse king. Unfortunately, off the west coast of Scotland, near Oban, Alexander II fell ill and died. He was succeeded by his son, Alexander III.

Like his father, King Alexander III wanted to claim the islands in the north and west for Scotland. King Alexander offered to buy the islands. This was, once again, refused.

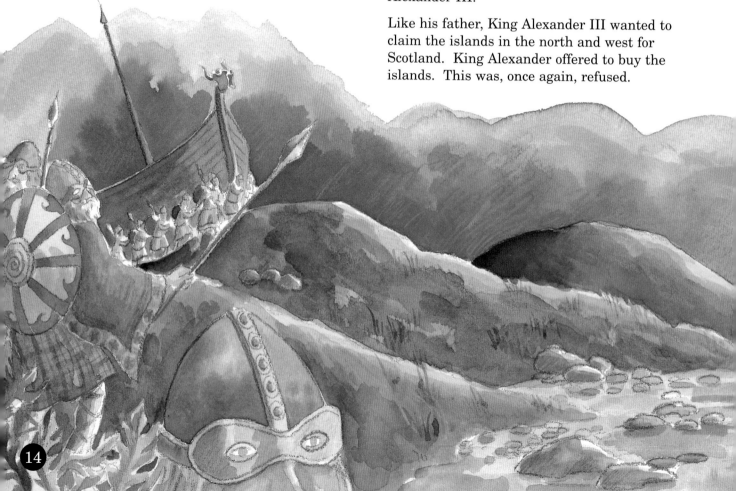

Meanwhile, a Scottish nobleman attacked the Norse settlement on the Isle of Skye.

King Haakon was very angry. He gathered together a huge fleet and set sail down the west coast of Scotland. When the ships reached the Firth of Clyde, in the Autumn of 1263, there was a terrible storm. Many of King Haakon's ships were blown onto the shore at Largs. King Alexander's men were waiting for them. Many Norsemen were killed. King Haakon survived and sailed back to the Orkney Isles where he died. His son, King Magnus, signed a treaty which gave the Scottish King the Western Isles, but not the Orkney and Shetland Isles.

King Haakon ordered the captains of his ships to carry their ships across land from Loch Long to Loch Lomond so that he could make an attack further inland.

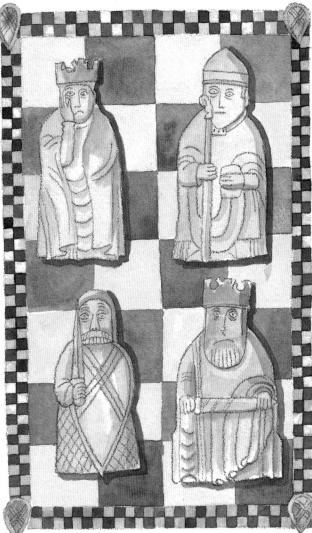

The Lewis chess pieces were found on the island of Lewis in 1831. The chess pieces are of Norse design, and were made of walrus ivory.
Here are four similar pieces. Design a pawn to go with the set.

15

The Maid of Norway, John Balliol & the Auld Alliance

The Maid of Norway

Queen Margaret was three years old when she became Queen of Scotland after the death of her grandfather King Alexander III in 1286. She was known as "The Maid of Norway" because her father was King Eric of Norway.

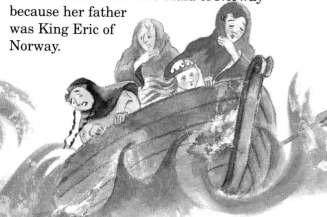

Six guardians looked after Scotland for four years until arguments about her succession among the Scots, English and Norwegians were settled. Unfortunately, the seven-year-old Queen Margaret died in Orkney, of seasickness, before she reached Scotland.

John Balliol

Scotland was left without a monarch when Queen Margaret died. Robert Bruce and John Balliol were among those who had claims to the throne. Both of them were descendants of David I. Edward I of England was asked for his help in choosing Scotland's next king. The English king chose John Balliol because he thought Balliol was someone who would do his bidding. John Balliol was crowned King in 1292. John Balliol did have support amongst the Scottish people. However, he did not have the right characteristics to be a strong leader. For these reasons he became known as "Toom Tabard" or "Empty Coat". We might call him a "stuffed shirt". He is remembered by his name rather than as King John I of Scotland.

Eventually, though, Balliol wanted to be free of the English kings. He refused to send soldiers to help the English fight the French and signed a treaty with the French king instead. This treaty began the "Auld Alliance". As a result King Edward marched into Scotland and took the Stone of Destiny. John Balliol gave up his throne and fled to France.

The Auld Alliance

The Auld Alliance was a treaty signed between King John Balliol of Scotland and King Philip of France in 1295. In it the countries agreed to help each other. The links between the two countries have been strong through the centuries. King James I sent Scottish soldiers to help Joan of Arc in 1428. From 1422 until 1792 the French king's bodyguard was made up of Scottish soldiers. In 1995 the Auld Alliance celebrated its 700th anniversary.

(A verse from "The Ballad of Sir Patrick Spens")
To Noroway, to Noroway,
 To Noroway o'er the faem;
 The King's daughter of Noroway,
 Tis thou maun bring her hame.

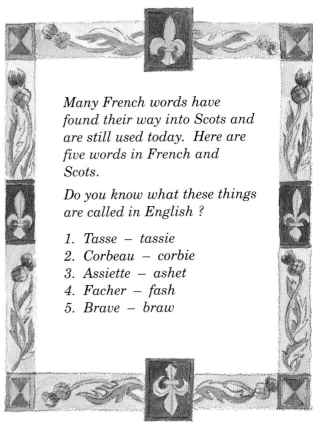

Many French words have found their way into Scots and are still used today. Here are five words in French and Scots.

Do you know what these things are called in English ?

1. *Tasse – tassie*
2. *Corbeau – corbie*
3. *Assiette – ashet*
4. *Facher – fash*
5. *Brave – braw*

John Balliol was summoned to King Edward's court to deal with petty matters. Once he was sent for to pay to an English wine merchant money that had been owed to him by King Alexander III of Scotland.

WILLIAM WALLACE

John Balliol fled to France leaving Scotland without its own monarch. Edward I of England took over Scotland. He put noblemen of his choosing in key roles to help him govern. The Scottish people were not treated fairly by these noblemen. Groups of Scots joined together to try to overthrow the English and restore John Balliol to the throne. An uprising was led by William Wallace and Andrew Moray.

Wallace and his army met the English army at Stirling in September 1297. The two armies faced each other across the River Forth at Stirling Bridge. The wooden bridge was narrow and only a small number of English soldiers could cross at one time. The land between the Scots and the bridge was very marshy. When the English soldiers had crossed the bridge they could not move very easily. The Scottish army attacked. The bridge was blocked by English soldiers and with it their escape route. Many English soldiers lost their lives when the bridge collapsed. Wallace and his soldiers won the Battle of Stirling Bridge. Wallace was made "Guardian of Scotland". Andrew Moray died from the wounds he received during the battle.

Edward I of England sent another army north. Wallace's army was beaten at Falkirk on 22nd July 1298. He escaped to France to look for help. When Wallace returned to Scotland he continued to fight for his country's freedom. On 3rd August 1305 Wallace was betrayed and taken prisoner near Glasgow. He was taken to London where he faced a charge of treason. Wallace was found guilty and executed on 23rd August 1305.

Did you know...?

... that in August 1296 King Edward I of England persuaded 2000 Scottish men to sign the "Ragman Roll". This document stated that the men who signed accepted that the English king was also king of Scotland. William Wallace did not sign this document.

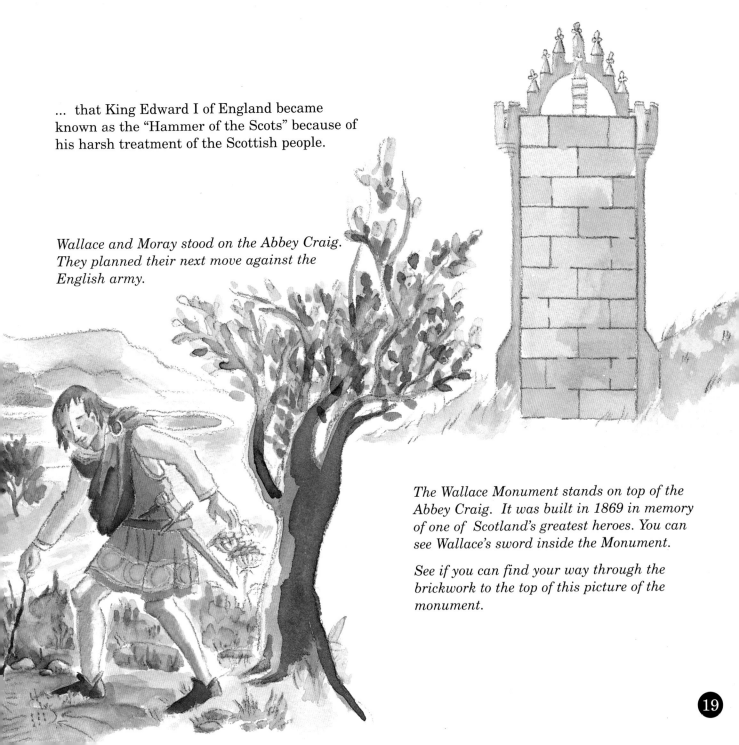

... that King Edward I of England became known as the "Hammer of the Scots" because of his harsh treatment of the Scottish people.

Wallace and Moray stood on the Abbey Craig. They planned their next move against the English army.

The Wallace Monument stands on top of the Abbey Craig. It was built in 1869 in memory of one of Scotland's greatest heroes. You can see Wallace's sword inside the Monument.

See if you can find your way through the brickwork to the top of this picture of the monument.

ROBERT THE BRUCE

For ten years Scotland was without a king. Then Robert the Bruce was crowned King Robert I of Scotland in 1306. Robert the Bruce was the grandson of Robert Bruce, Lord of Annandale, who had been a contender for the throne at the same time as John Balliol. At the time of his coronation Robert the Bruce did not have enough support amongst the Scottish people to drive the English out of Scotland.

In the spring of 1307 several members of the Bruce family were taken prisoner by the English. Robert the Bruce went into hiding. Legend has it that Bruce was sitting in a cave, possibly on Arran, thinking about what he could do next. It seemed a very hard task to beat the English king. As he thought, he watched a spider spinning its web. The spider tried to complete its web by swinging from one part of the cave's roof to another. It tried several times before eventually succeeding. The spider inspired Bruce to "try, try and try again".

Support grew for Robert the Bruce's cause and it was a large army that he led on to the battlefield at Bannockburn on 24th June 1314. But Bruce's army was still smaller than the English army it faced. The English army was led by Edward II, son of Edward I. Bruce had chosen the place where he would meet the English army very carefully. This was one of the most important factors which helped the Scottish army win the battle.

When Bruce's army pushed forward the English army had very little room to move as they had their backs to marshy ground. There was great confusion amongst the English ranks. Edward II fled the field leaving his men to surrender or die.

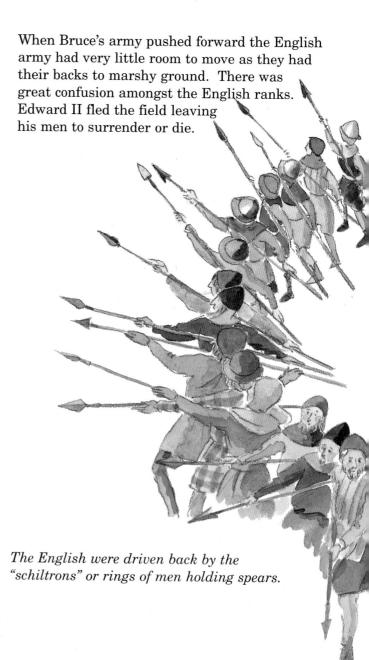

The English were driven back by the "schiltrons" or rings of men holding spears.

Did you know...?

... that Robert the Bruce's daughter, Marjorie Bruce, married Walter the Steward. Their son became King Robert II, founder of the Stewart Royal House.

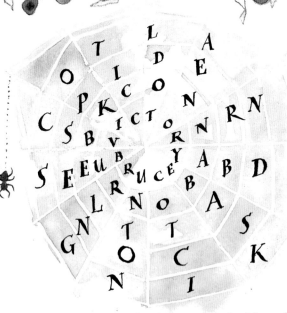

The Declaration of Arbroath was signed in April 1320 by the most important men in Scotland. By signing it they gave their support to their King, Robert the Bruce, and to the independence of their country.

The spider has caught eight words in his web. They all have something to do with Robert the Bruce. The words spiral inwards in a clockwise direction. The spider shows you where to start. See how many you can find.

King James I—"The Law Giver"

King James I returned to Scotland in 1424 after eighteen years in England. He was twenty-nine. When he was crowned at Scone in 1424 he had in fact been King since 1406.

It was the beginning of a troubled time for Scotland's monarchs. Invariably, the king or queen inherited the throne as a child. Scotland was governed by regents until the monarch was old enough to rule in their own right. The regent was usually one of Scotland's most powerful noblemen. This in itself caused arguments between the noblemen. When the Scottish king or queen was old enough to govern they found they had an uphill struggle to assert themselves against the power of the noblemen.

On his return to his homeland King James found that the noblemen had become very powerful. He decided to bring them into line and show them that he was the most powerful man in Scotland. The changes that King James wanted to make did not stop at the nobility. He made laws which affected the ordinary people of Scotland too. For example, he passed a law which allowed poor people to get free legal advice should they need it. We have something similar today called Legal Aid.

King James also made laws which stopped people doing certain things. For example, fishing for salmon at the wrong time of year was not allowed. Playing football was forbidden, because King James wanted people

to take up other sports like hunting, hawking and fencing. James I became known as *Rex Legifer*, the Law-Giver King.

Not everyone was pleased with the changes King James made. One group of noblemen was particularly angry with him. One of the leaders of the group was the King's cousin, Sir Robert Stewart. King James I was murdered by the noblemen in Perth on the night of 20th February 1437.

Did you know...?

... that at the age of eleven King James was sent to France. On the way there he was kidnapped by pirates and taken to the English King. He remained in England for eighteen years, and became famous there as a court poet.

... that there were wolves still living in the wild in Scotland in the 15th century. King James I ordered that the number of wolves should be kept down.

Football was not allowed to be played after King James I passed a law forbidding it.

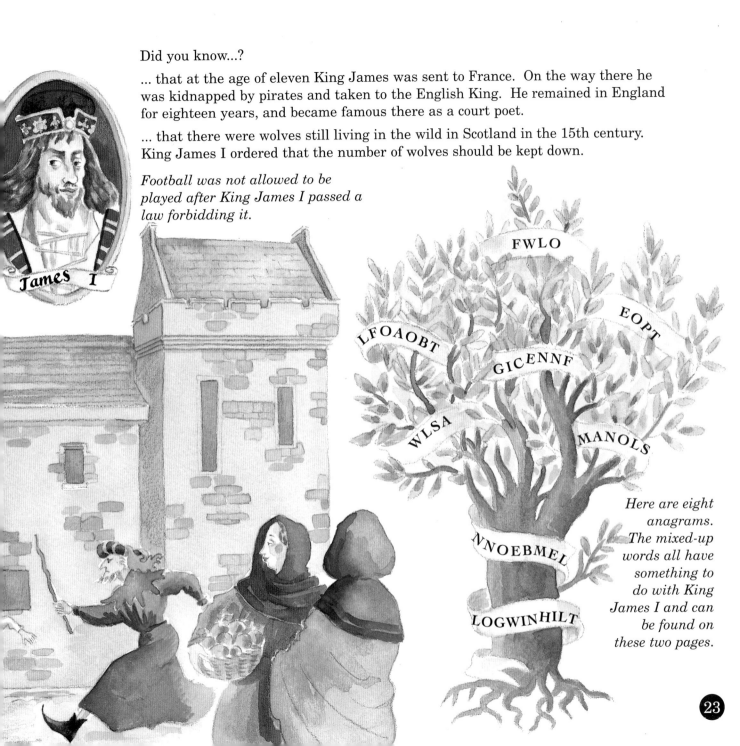

James I

FWLO

EOPT

LFOAOBT

GICENNF

WLSA

MANOLS

NNOEBMEL

LOGWINHILT

Here are eight anagrams. The mixed-up words all have something to do with King James I and can be found on these two pages.

23

KING JAMES II 1430–1460/
KING JAMES III 1452–1488

King James II was only six when he was crowned in 1437. He was eighteen when he started to govern Scotland himself. While James was too young to rule, Scotland was ruled by a series of regents, including members of the Douglas family. The Douglases were one of the most powerful families in Scotland. One of the first things James II did when he took control of his country was to reduce the power of this family. He beat a Douglas army in battle in 1455 and took or destroyed their castles. James II was very interested in cannons. He used the massive "bombard" cannon, Mons Meg, to help him in his campaign against the Douglases.

James II liked to watch his soldiers firing the big cannons. In 1460, during a siege of Roxburgh Castle, King James was standing close to a cannon when it exploded. The King was seriously injured and died.

Mons Meg was a gift from the Duke of Burgundy to King James II in 1457. It was made in the Belgian town of Mons and is a type of medieval siege gun. The cannonballs could be fired about 3.5 km. The only drawback was that it took 30 to 60 minutes to reload. You can see Mons Meg today if you visit Edinburgh Castle.

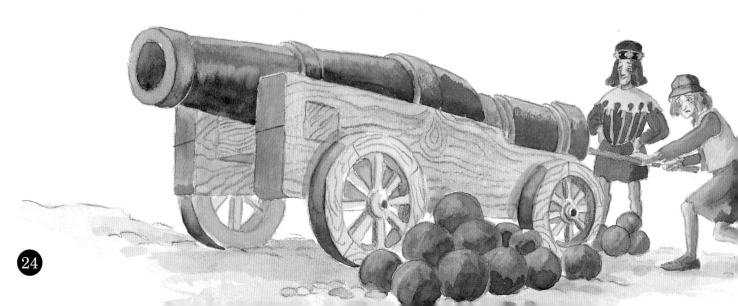

King James III

King James III was eight when he came to the Scottish throne in 1460. In 1469 he married Princess Margaret, the daughter of King Christian. King Christian ruled Norway, Sweden, Denmark and the Orkney and Shetland Isles. As part of the marriage agreement or dowry King Christian pawned the Orkney Isles to James III until he could afford to pay him some money.

King James III had problems with the powerful Scottish noblemen during his reign. They felt that the King spent too much time with his friends and not enough time running his country. James III was murdered near Stirling after being defeated at the Battle of Sauchieburn in 1488, where he faced an army gathered by the disgruntled Scottish noblemen.

James III was interested in art, music and science. He was also interested in architecture and he may have been involved in the planning and early construction of the Great Hall at Stirling Castle.

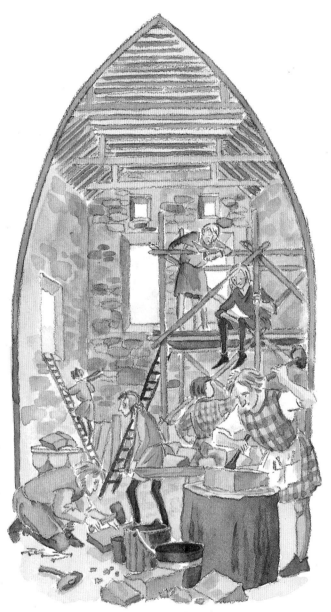

The Great Hall at Stirling Castle.

25

King James IV—The Battle of Flodden

In 1503 James IV married Margaret Tudor. She was the daughter of Henry VII of England. To mark the occasion the two kings signed a treaty which agreed peace between their two countries.

The peace lasted until the death of the English king in 1509. He was succeeded by his warlike son Henry VIII. The new king of England wanted to rule Scotland himself. Henry VIII devised a plan which would provoke King James and his army to help their Auld Alliance friends, the French. The English king sent an army to wait in the north of England while he fought a French army in France. It went just as King Henry planned. King James and his army marched across the border and attacked three English castles. King James hoped that by invading England the English king would not have enough soldiers to fight in two places at once. This would ease the pressure on his French allies.

King James and his army set up camp on Flodden Edge in Northumberland. The leader of the English army moved his men so that they blocked the Scottish army's escape route. When the fighting began on September 9th 1513 it was clear that the Scottish army could not match the well trained and armed English army. By the end of the day as many as 10,000 Scots were dead or seriously injured. Amongst those who died were many of Scotland's leading lords and clergymen. King James IV also lost his life fighting courageously to the end.

Did you know...?

... that in portraits, James IV appears without a beard. In fact, James IV did have a beard but the artists of the time did not think it was fashionable so they painted him without one.

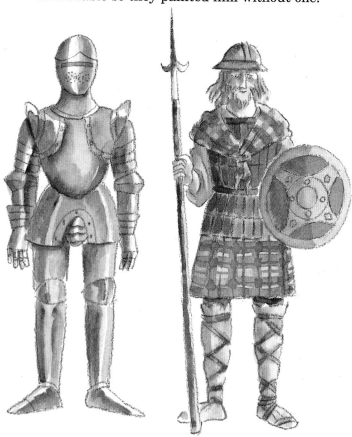

The Scottish army was no match for the well trained English army.

... that King James IV was a very popular and clever king. He could speak several languages, including Gaelic, Latin, French and German. He was very interested in medicine and liked to watch operations being performed. He had a similar interest in dentistry and paid people to allow him to pull their teeth out.

James **IV**

...that King James IV had a huge warship built. It was called the "Great Michael". The warship was said to be about 80 metres long and had walls which were about 3 metres thick.

It was so big that just about every oak tree in Fife had to be cut down to build it. There was no other ship in the world as big as the "Great Michael" at that time.

There is a lament, or sad tune, played by a lone piper which was written in honour of the soldiers who died at the Battle of Flodden. Do you know what the lament is called and on which special day each year you might hear it being played ?

KING JAMES V—"THE POOR MAN'S KING"

Yet again Scotland's king was a babe-in-arms. James V was crowned at the age of seventeen months in 1513 and during his childhood Scotland was again ruled by regents. At the age of sixteen James V decided that he was ready to rule his country himself. One of the first things James V did when he took control of his country was to deal severely with the noblemen who had treated him badly when he was younger. King James travelled around Scotland dealing with other noblemen who were becoming too powerful. The common people of Scotland liked what their king was doing and James V was known as the "poor man's king".

King James liked the company of the common folk of Scotland. He would disguise himself as an ordinary farmer and wander around the countryside mixing with his people. On one occasion, he was set upon by a band of thieves. He was rescued by Jock Howieson, a miller who lived at Cramond. Jock Howieson thought he had helped a farmer on his way to Edinburgh,

not the king. The miller was invited to Holyrood. When King James entered the room everyone took off their hats except Jock. The miller then recognised the king as the man he had rescued from the thieves. Realising one of them had to be the king, since they were the only people with their hats on, Jock jokingly said, "Then it must be either you or me, for all but us are bareheaded". Jock was rewarded by the gift of a farm near Cramond. Other kings and queens later visited Jock's descendents in honour of the time he saved James V's life.

Did you know...?

... that James V set up the Court of Session. The Court of Session is still the main civil court in Scotland.

... that James V had a lot of building work carried out at Falkland Palace.

... that the Stirling Heads were carved for King James V. You can still see the Stirling Heads in Stirling Castle.

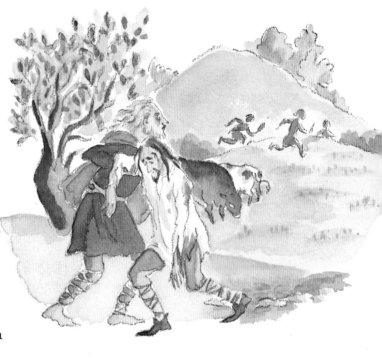

King James V was rescued by Jock Howieson after being set upon by a band of thieves.

If you could disguise yourself so well that no one could recognise you, where would you go and what would you do ?

Mary, Queen of Scots—Escape from Lochleven Castle

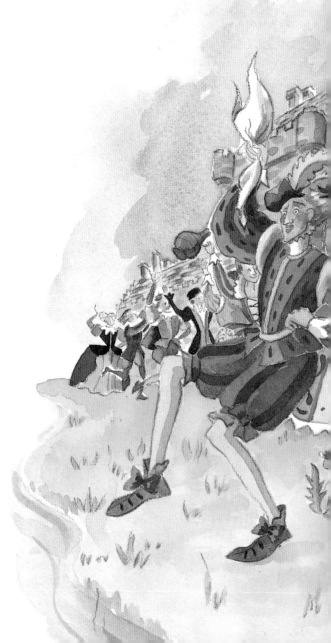

Mary, Queen of Scots is one of Scotland's famous monarchs. Here is a "potted history" of the important dates and facts of her life. Four of the important events have been missed out. Can you find out what they are, and put the correct event by the correct date?

1542 – Mary, Queen of Scots is born.
1543 – 1.
1548 – Mary, Queen of Scots leaves for France.
1561 – Mary, Queen of Scots returns to Scotland.
1565 – 2.
1566 – David Riccio is murdered.
1566 – Prince James is born.
1567 – 3.
1568 – The Battle of Carberry Hill
1568 – 4.
1568 – The Battle of Langside
1587 – Mary, Queen of Scots is executed.

Mary, Queen of Scots was imprisoned in Lochleven Castle after the Battle of Carberry Hill in 1567. The castle was sited on an island in the middle of Loch Leven. Queen Mary had been deserted by her third husband, the Earl of Bothwell. However, she was not without friends amongst the people who lived in the castle. The castle was the home of Sir William Douglas and his family. During her stay in Lochleven Castle, Queen Mary was forced to abdicate, or give up her throne. Her one-year-old son was crowned King James VI of Scotland in 1567.

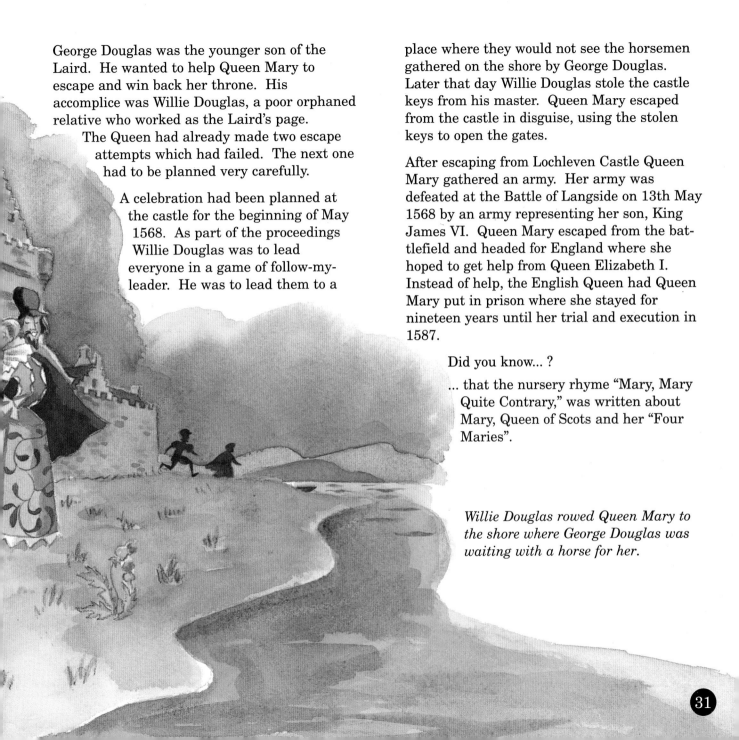

George Douglas was the younger son of the Laird. He wanted to help Queen Mary to escape and win back her throne. His accomplice was Willie Douglas, a poor orphaned relative who worked as the Laird's page.

The Queen had already made two escape attempts which had failed. The next one had to be planned very carefully.

A celebration had been planned at the castle for the beginning of May 1568. As part of the proceedings Willie Douglas was to lead everyone in a game of follow-my-leader. He was to lead them to a place where they would not see the horsemen gathered on the shore by George Douglas. Later that day Willie Douglas stole the castle keys from his master. Queen Mary escaped from the castle in disguise, using the stolen keys to open the gates.

After escaping from Lochleven Castle Queen Mary gathered an army. Her army was defeated at the Battle of Langside on 13th May 1568 by an army representing her son, King James VI. Queen Mary escaped from the battlefield and headed for England where she hoped to get help from Queen Elizabeth I. Instead of help, the English Queen had Queen Mary put in prison where she stayed for nineteen years until her trial and execution in 1587.

Did you know... ?

... that the nursery rhyme "Mary, Mary Quite Contrary," was written about Mary, Queen of Scots and her "Four Maries".

Willie Douglas rowed Queen Mary to the shore where George Douglas was waiting with a horse for her.

KING JAMES VI & I—THE UNION OF THE CROWNS

James VI had mixed feelings about his mother, Mary, Queen of Scots. He had been brought up by a guardian and did not know Mary. On the one hand he had feelings of loyalty because she was his mother. On the other hand he knew Mary hoped that one day she would reclaim her throne; *his* throne!

King James had his sights set on the English throne too. Elizabeth I had not married and had no children. After Mary, the Scottish King had the strongest claim to the English throne. In 1586 King James accepted money from the English Queen in return for peace between the two countries. When Mary was executed no-one stood between him and the English throne. James VI did not trust the Scottish noblemen. He chose eight men of lower rank to advise him. King James was able to control them in a way he could not have controlled the noblemen. These eight men became known as "The Octavians".

It was not only the Scottish noblemen who troubled the King. He also had troubles in his dealings with the Scottish Kirk. He believed that he was the Head of State and for James this meant Head of the Kirk as well. The Kirk believed that Jesus Christ was the Head of both State and the Kirk, and that the King, like themselves, was his subject. This made King James answerable to the ministers, who were Christ's representatives on earth.

James VI became King of England in 1603. This made him James VI of Scotland and James I of England. That is why he is known as James VI and I. King James chose to live in London and returned to Scotland only once more. The visit was in 1617 and was made in order to push reforms through the Scottish Kirk's General Assembly. The reforms were very unpopular amongst the Kirk's members.

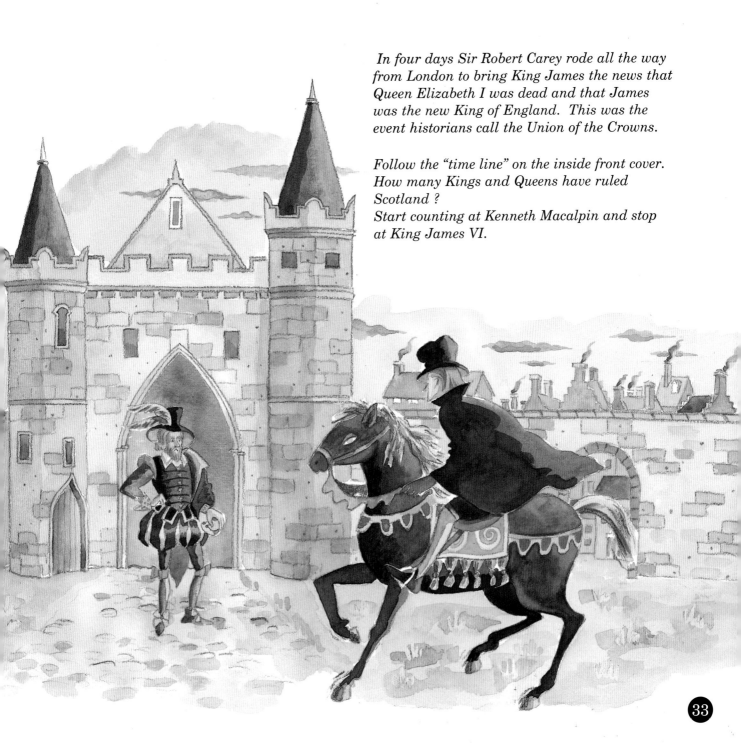

In four days Sir Robert Carey rode all the way from London to bring King James the news that Queen Elizabeth I was dead and that James was the new King of England. This was the event historians call the Union of the Crowns.

Follow the "time line" on the inside front cover. How many Kings and Queens have ruled Scotland ?
Start counting at Kenneth Macalpin and stop at King James VI.

KINGS AND QUEENS AFTER THE UNION OF THE CROWNS

In 1603 the Crowns of Scotland and England were joined together and Great Britain was created. It was ruled by one monarch. Just over a century later, this Union of the Crowns was followed by the Union of the two Parliaments (1707).

This portrait gallery shows some of the British Kings and Queens who have reigned in Great Britain since the Union of the Crowns.

JAMES VI & I (1603–25)

CHARLES I (1625–49)

"THE COMMONWEALTH" (1649–60)

CHARLES II (1660–85)

JAMES VII & II (1685–88)

WILLIAM AND MARY (1688–1702)

ANNE (1702–14)

GEORGE I (1714–27)

GEORGE II (1727–60)

GEORGE III (1760–1820)

GEORGE IV (1820–30)

WILLIAM IV (1830–37)

VICTORIA (1837–1901)

EDWARD VII (1901–10)

GEORGE V (1910–36)

EDWARD VIII (1936)

GEORGE VI (1936–52)

ELIZABETH II (1952–)

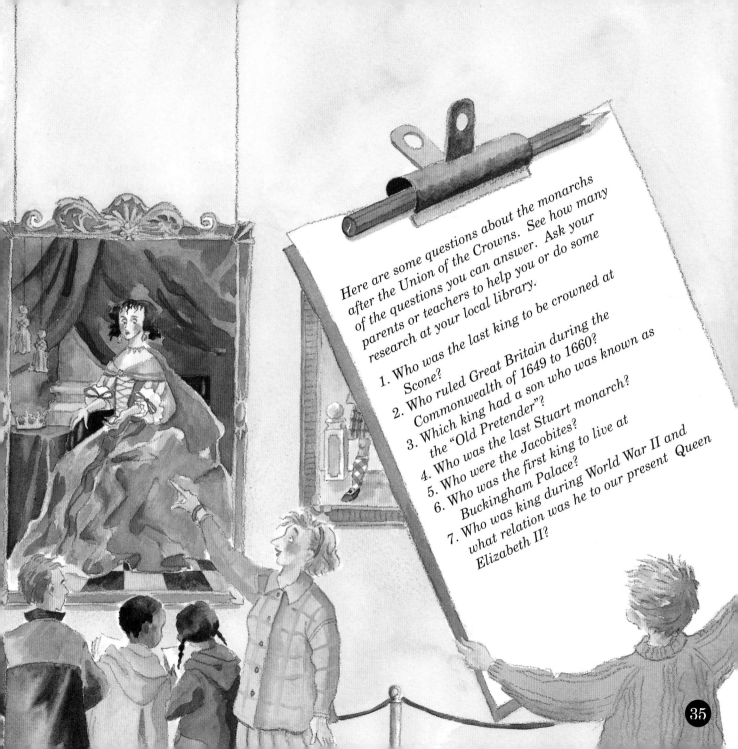

Here are some questions about the monarchs after the Union of the Crowns. See how many of the questions you can answer. Ask your parents or teachers to help you or do some research at your local library.

1. Who was the last king to be crowned at Scone?

2. Who ruled Great Britain during the Commonwealth of 1649 to 1660?

3. Which king had a son who was known as the "Old Pretender"?

4. Who was the last Stuart monarch?

5. Who were the Jacobites?

6. Who was the first king to live at Buckingham Palace?

7. Who was king during World War II and what relation was he to our present Queen Elizabeth II?

ROYAL VISITS TO SCOTLAND

King George IV

King George IV visited Scotland in 1822. It was the first time a reigning British monarch had visited Scotland in nearly 200 years. Sir Walter Scott helped to plan King George's visit. There were many grand and splendid events. King George had two kilts made for the occasion.

King George's boat docked at Leith on 14th August 1822. The following day there was a procession from Leith to the Palace of Holyroodhouse. The King stayed at Dalkeith Palace. The Palace of Holyroodhouse was used for glamorous social events during the King's visit. The other great event was the parading of the Honours or Crown Jewels of Scotland. The Honours were carried in front of the King from Holyroodhouse to Edinburgh Castle.

Queen Victoria

Queen Victoria made frequent visits to Scotland during her reign. After the death of Prince Albert, in 1861, the Queen spent longer periods of time at Balmoral Castle. She travelled from Ballater on the newly opened Deeside railway to visit her friends in the surrounding area. Queen Victoria made one particularly memorable visit to Edinburgh in August 1881. The Queen was to attend a review of 40,000 soldiers in the Queen's Park in Edinburgh. The weather was terrible, it had not stopped raining all day. Nevertheless, armed with an umbrella, Queen Victoria attended the review. This review became known as the "Wet Review", because of the awful weather.

Queen Elizabeth II

Queen Elizabeth II visits Scotland each year. In the early summer she stays at the Palace of Holyroodhouse where she holds garden parties to meet a cross-section of Scots. The Queen carries out other official duties while she is in Scotland at this time. Later on in the year the Queen has a holiday at Balmoral Castle. Queen Elizabeth has made more visits to Scotland than any monarch since the Union of the Crowns in 1603.

Some of these visits have been very special. Soon after her coronation in 1953 the Queen was presented with the Honours of Scotland at a special ceremony in St Giles Cathedral, Edinburgh. Following the ceremony, Queen Elizabeth and Prince Philip travelled by horsedrawn carriage to Edinburgh Castle where the Queen received the keys to the Castle.

If you could be a king or queen for a day where would you like to visit?

Queen Elizabeth II visited Scotland a few weeks after her coronation. The Honours of Scotland were presented to the Queen at a special ceremony in St Giles Cathedral, Edinburgh.

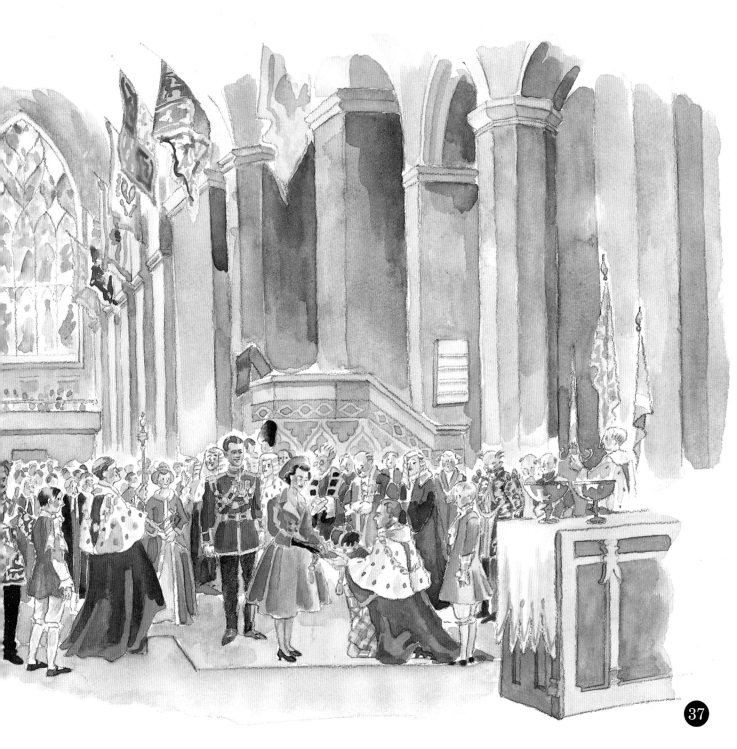

ROYAL RESIDENCES IN SCOTLAND

The Palace of Holyroodhouse

The first royal residence at Holyrood was part of the Abbey buildings founded by David I. It was the Abbey's guest house and was more comfortable than Edinburgh Castle. James IV and James V both carried out building work at the Palace. Charles II completed the building in 1676. The roof of Holyrood Abbey collapsed in 1688. You can still see the ruins of the Abbey beside the Palace. Queen Elizabeth II stays at the Palace of Holyroodhouse when she visits Edinburgh in the summer.

You can see King James V's Coat of Arms carved on a wall near the gates at the Palace of Holyroodhouse. Do you know the name of the mythical creature that appears on the Coat of Arms?

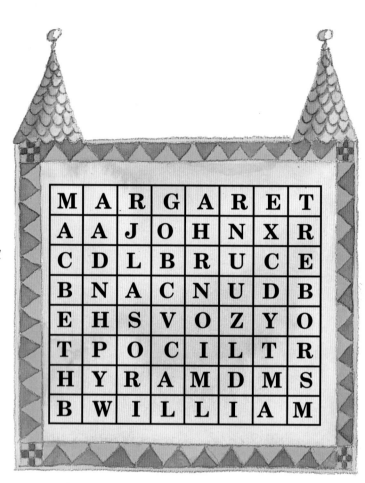

M	A	R	G	A	R	E	T
A	A	J	O	H	N	X	R
C	D	L	B	R	U	C	E
B	N	A	C	N	U	D	B
E	H	S	V	O	Z	Y	O
T	P	O	C	I	L	T	R
H	Y	R	A	M	D	M	S
B	W	I	L	L	I	A	M

Hidden in this word square are the names of ten Scottish kings and queens. See how many you can find.

Balmoral Castle

Queen Victoria and her husband, Prince Albert, decided that they would like a "holiday home" in Scotland. The new castle was to be sited in a place which would be good for their health, and Deeside seemed to have the right qualities. Prince Albert helped to design the new royal residence which was finished in 1856. After Albert died, Queen Victoria spent almost a third of most years at Balmoral.

Balmoral has been a favourite "holiday home" for successive royal families since the time of Queen Victoria and Prince Albert. Queen Elizabeth II and Prince Philip spend about eight weeks at Balmoral each year. Today Balmoral is a peaceful haven where the royal family can rest.

Prince Albert helped to design Balmoral Castle. The Castle was completed in 1856.

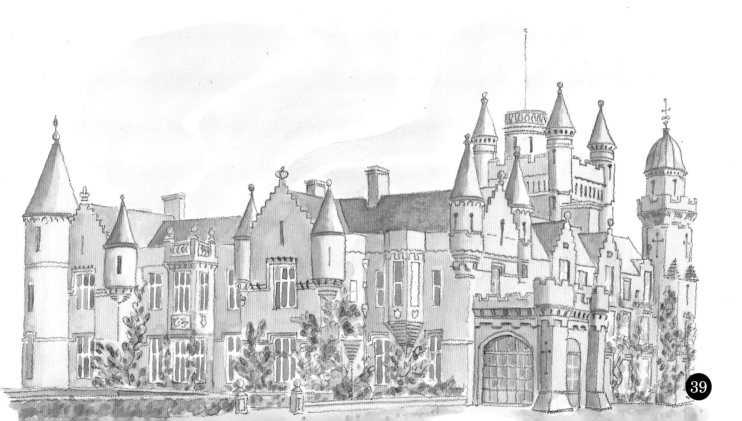

PLACES TO VISIT / ANSWERS

Here is a list of places of interest to visit which have connections with Scottish Royalty and are mentioned in this book.

1. Edinburgh Castle
2. The Palace of Holyroodhouse, Edinburgh
3. The Scottish National Portrait Gallery, Edinburgh "Dynasty" Exhibition
4. Dunfermline Abbey, Fife
5. The Wallace Monument, Stirling
6. Stirling Castle
7. The Bannockburn Heritage Centre, Stirling
8. Scone Palace, Perthshire
9. Linlithgow Palace, West Lothian
10. Falkland Palace, Fife
11. Lochleven Castle, Kinross-shire
12. Dunnottar Castle, near Stonehaven, Kincardineshire
13. Balmoral Castle, Aberdeenshire

As opening times of these places may vary it would be a good idea to check opening time details with the local Tourist Information Office.

Answers

Page 4: (Northern) Ireland
Page 8: aerial, bike, camera, headphones, rucksack, pylons.
Page 10: No. 4
Page 12: Robert the Bruce, Robert II & Robert III / John Balliol
Page 16: 1. cup 2. crow 3. plate 4. fret / anger 5. fine
Page 20: Bruce / King / Scotland / Scone / Spider / Battle / Bannockburn / Victory

Page 22: 1. wolf 2. football 3. poet
4. fencing 5. laws 6. noblemen
7. salmon 8. Linlithgow
Page 26: "The Flowers of the Forest"/ Special Day – Remembrance Sunday
Page 30 1. The Coronation of Mary, Queen of Scots. 2. Mary, Queen of Scots marries Lord Darnley. 3. Lord Darnley is murdered.
 4. Mary, Queen of Scots escapes from Lochleven Castle.
Page 32: 41 kings and queens
Page 34: 1. King Charles II 2. Oliver Cromwell
3. King James VII & II 4. Queen Anne
5. The supporters of the exiled Stuart kings
6. King George III 7. King George VI / father
Page 38:

M	A	R	G	A	R	E	T
A	A	J	O	H	N	X	R
C	D	L	B	R	U	C	E
B	N	A	C	N	U	D	B
E	H	S	V	O	Z	Y	O
T	P	O	C	I	L	T	R
H	Y	R	A	M	D	M	S
B	W	I	L	L	I	A	M